Why Art?

Editor: Gary Groth
Designers: Eleanor Davis and Keeli McCarthy
Associate Publisher: Eric Reynolds
Publisher: Gary Groth

Featuring a cameo by Sophia Foster-Dimino, whose incredible
collected comics, *Sex Fantasy*, is out now from Koyama Press. Special
thanks to ICON 09, Esther Pearl-Watson, Drew Weing, Katherine
Guillen, Sophia Foster-Dimino, Secret Twitter, and all the fine people
at Fantagraphics Books.

Fantagraphics Books, Inc.
7563 Lake City Way NE
Seattle, WA 98115

www.fantagraphics.com
Facebook.com/Fantagraphics
@fantagraphics.com

ISBN: 978-1-68396-082-9
Library of Congress Control Number: 2017950384
First Fantagraphics Books edition: February 2018

Printed in China

Why Art?

Fourth Edition

ELEANOR DAVIS
Fantagraphics Books

WHY ART?

Before we can answer that question, let's explore some examples of different kinds of artworks. The most basic category of artwork is, of course, *Color.*

ORANGE ARTWORKS

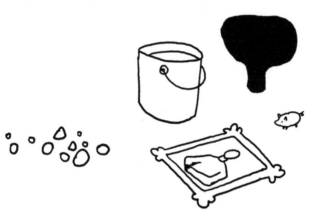

BLUE ONES

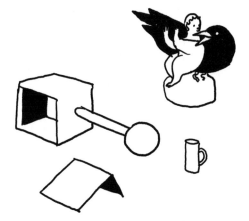

BOTH ORANGE
& BLUE ELEMENTS

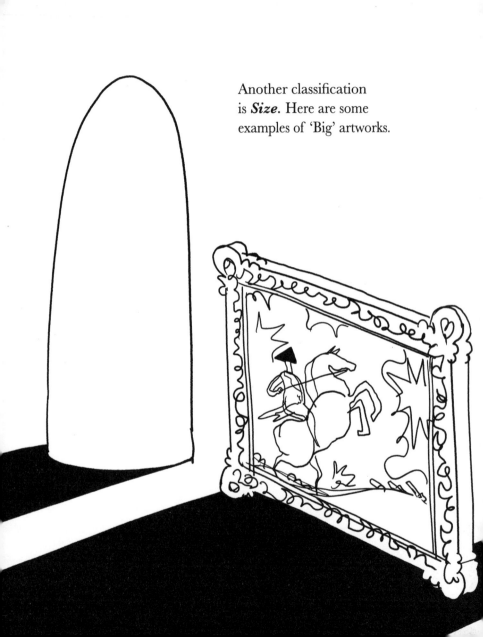

Another classification is *Size.* Here are some examples of 'Big' artworks.

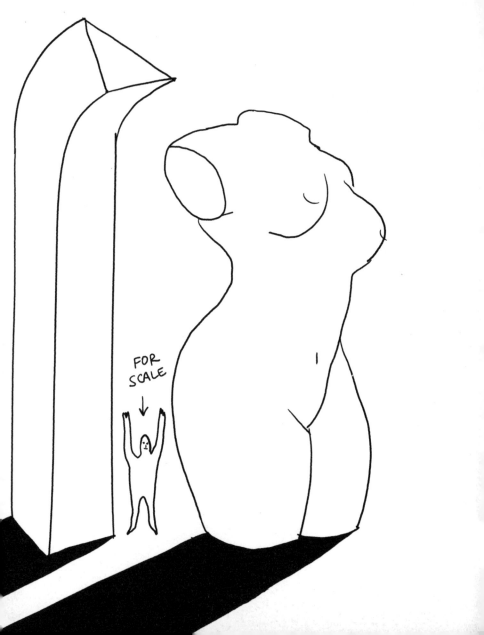

FOR
SCALE

These artworks would be
called 'Small,' or 'Petite.'

FOR
SCALE

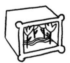

However, not all art should be categorized aesthetically. Many artworks are primarily intellectual, and can be categorized by either the intent of the artist or the response of the audience.

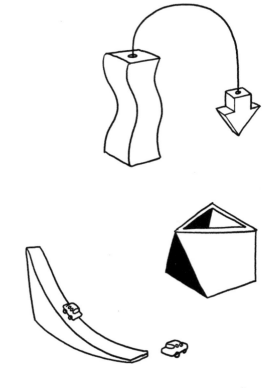

"MAKES YA THINK"

As artists, we must always consider —
what is our audience searching for?
This *Mask* artwork gives pleasure to
the wearer by allowing him or her to
become more physically attractive.

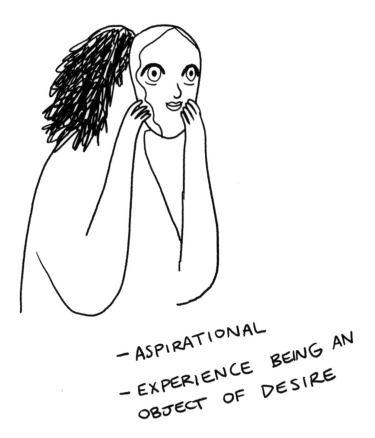

- ASPIRATIONAL
- EXPERIENCE BEING AN OBJECT OF DESIRE

An 'Ugly Mask' has
advantages as well.

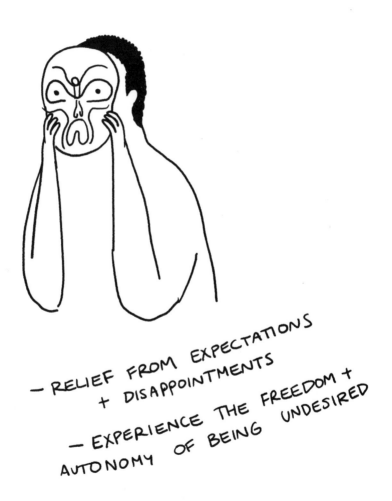

— RELIEF FROM EXPECTATIONS + DISAPPOINTMENTS

— EXPERIENCE THE FREEDOM + AUTONOMY OF BEING UNDESIRED

'God Masks' can be used
for purposes both spiritual
and worldly.

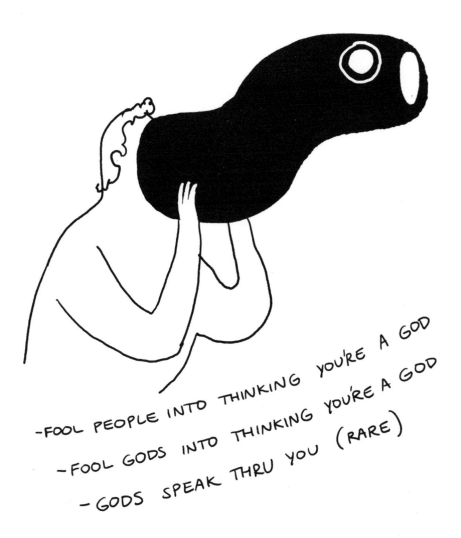

-FOOL PEOPLE INTO THINKING YOU'RE A GOD
-FOOL GODS INTO THINKING YOU'RE A GOD
-GODS SPEAK THRU YOU (RARE)

Finally, 'Animal Masks' —
'The Wolf' is a classic.

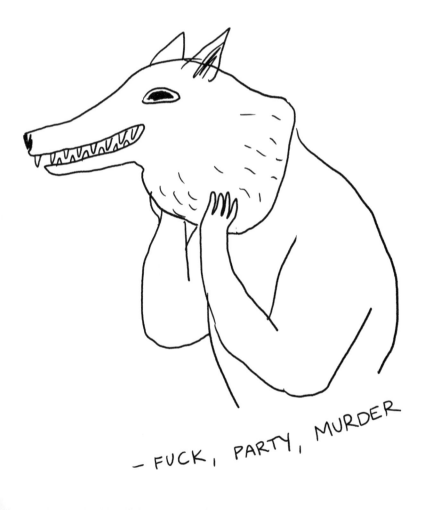

— FUCK, PARTY, MURDER

Mirror artworks can be extremely compelling.

— FLATTERING
MIRRORS

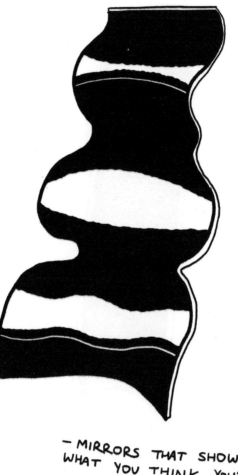

— MIRRORS THAT SHOW
WHAT YOU THINK YOU'RE
LIKE

—MIRRORS THAT SHOW US
WHEN WE'RE VERY, VERY OLD

The regular 'Ordinary Mirror' continues to fascinate both artist and audience alike.

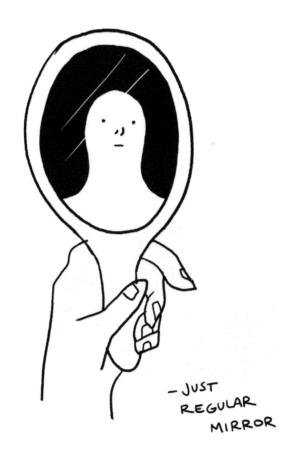

– JUST
REGULAR
MIRROR

Many artworks are *Edible*.

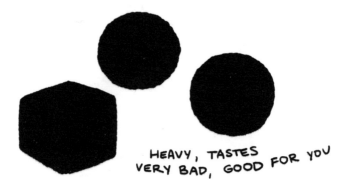

HEAVY, TASTES
VERY BAD, GOOD FOR YOU

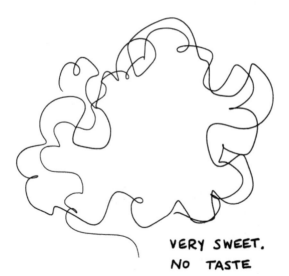

VERY SWEET.
NO TASTE

Some artworks are
just beautiful empty
'Containers,' to put
other things inside.

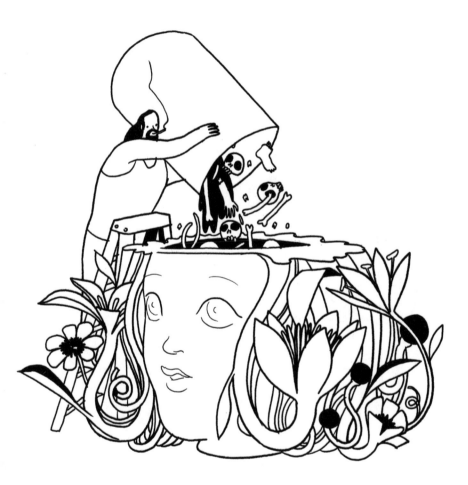

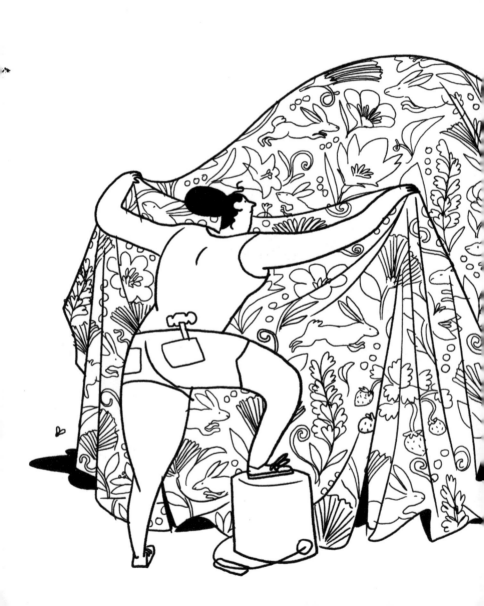

Or beautiful 'Fabrics' to drape over other things and hide them away.

These **_Concealment_** artworks have great commercial value, but the artists who make them can get defensive.

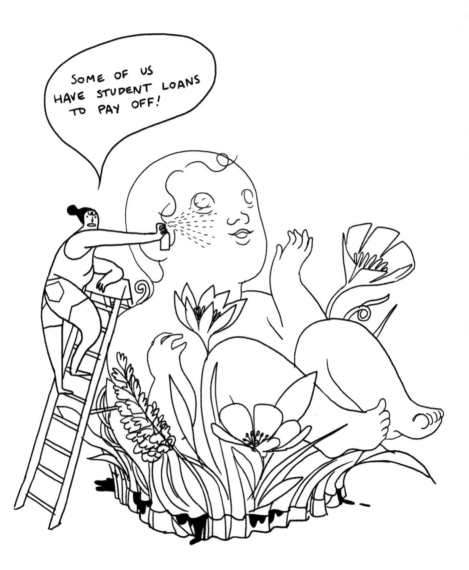

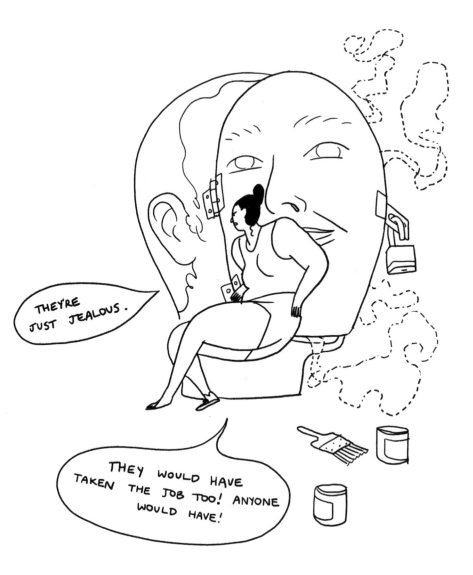

There are other artworks that are meant to remind the audience of things we'd rather forget, things so awful they shouldn't be true.

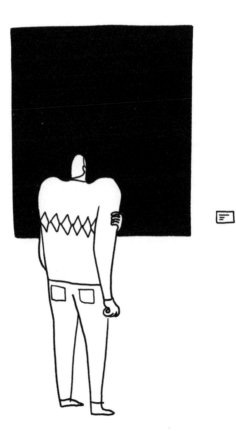

But they are true, and being reminded makes us feel like the tops of our heads are coming off. It makes us feel like the sky is wrinkling and running like wet tissue paper, like we're being dragged down into deep water by many drowning hands, and we have to tear and rip at the hands to make them let go.

Many people try hard
to not look at this sort
of artwork.

And if we accidentally do, we quickly go to eat some of the 'Sweet' artwork with no taste.

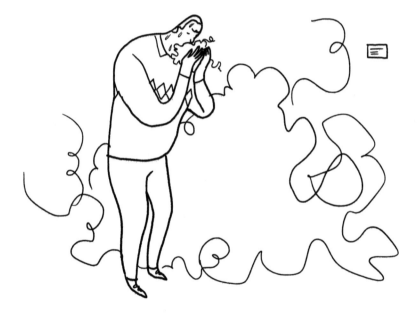

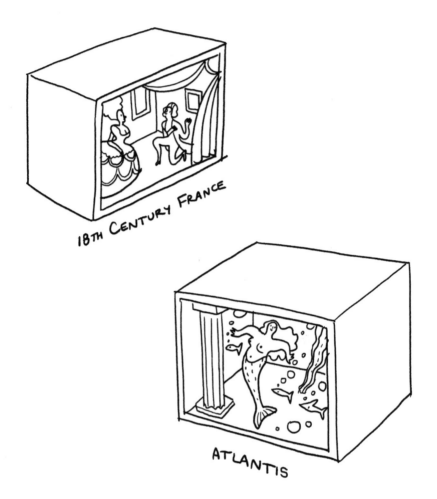

18TH CENTURY FRANCE

ATLANTIS

Shadowbox artworks can let you leave your ordinary life completely.

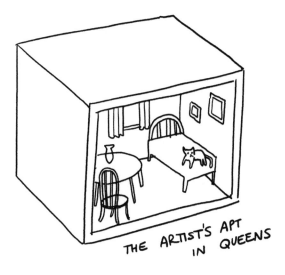

THE ARTIST'S APT IN QUEENS

Someone has crawled
into this Shadowbox
artwork.

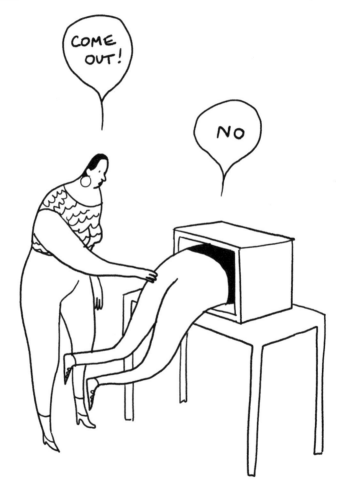

What is his experience
in there?

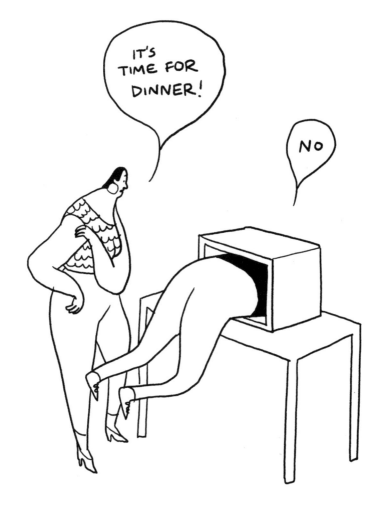

For some artworks, the response goes beyond an intellectual one.

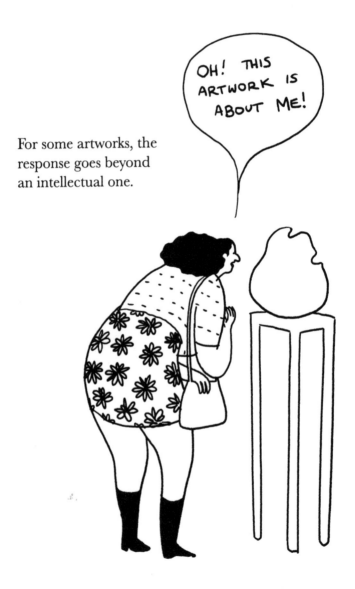

OH! THIS ARTWORK IS ABOUT ME!

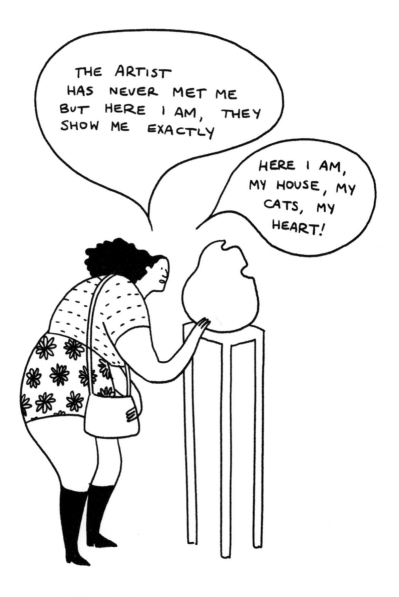

Because artwork is often viewed by
a wide audience, conflicts can arise.

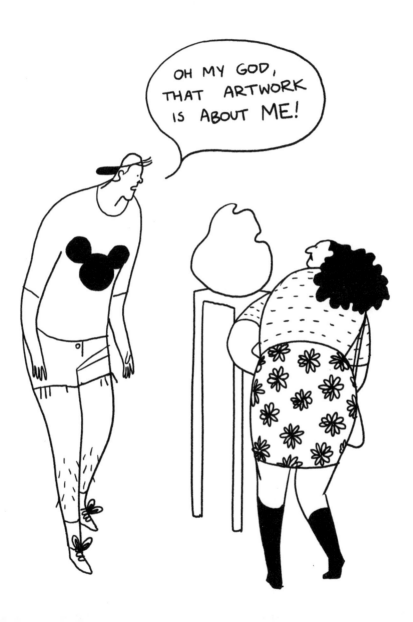

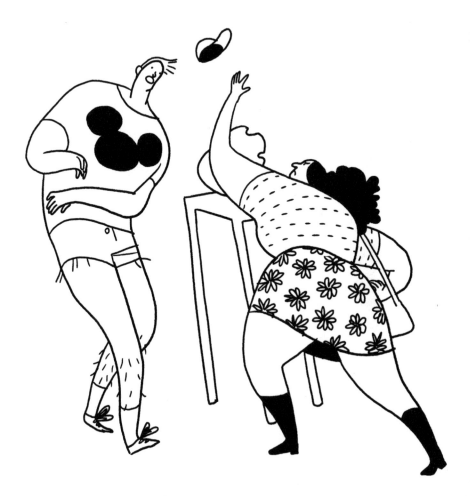

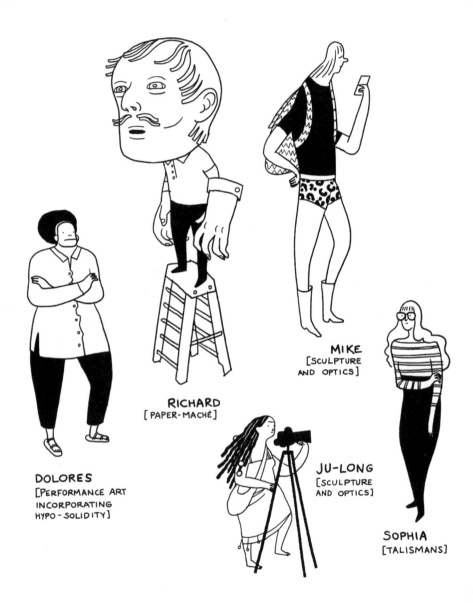

DOLORES
[PERFORMANCE ART
INCORPORATING
HYPO-SOLIDITY]

RICHARD
[PAPER-MACHÉ]

MIKE
[SCULPTURE
AND OPTICS]

JU-LONG
[SCULPTURE
AND OPTICS]

SOPHIA
[TALISMANS]

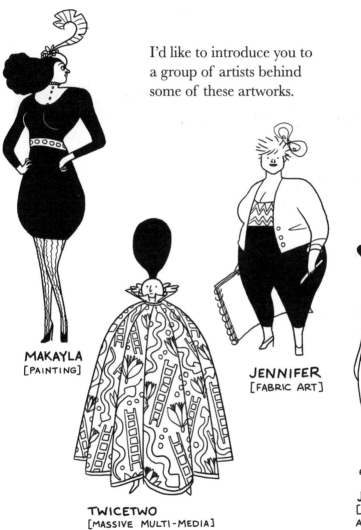

I'd like to introduce you to a group of artists behind some of these artworks.

MAKAYLA
[PAINTING]

TWICETWO
[MASSIVE MULTI-MEDIA]

JENNIFER
[FABRIC ART]

JOSÉ
[CONCRETE
AND FONDANT]

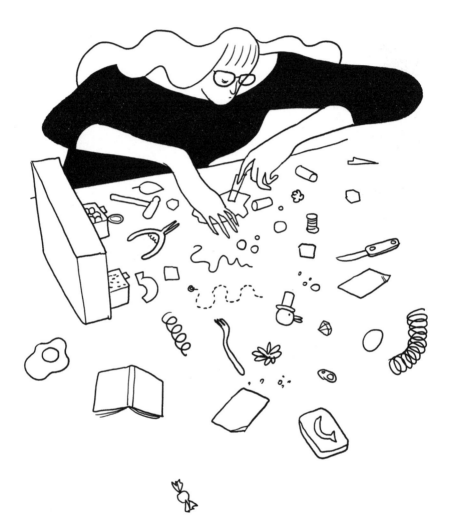

Each of *Sophia*'s
artworks comes with
instructions that read:
*'Wear your talisman at all
times in case of emergency.'*

*"When a crisis arises,
 gently shake."*

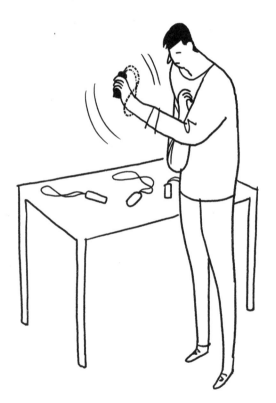

A little musical
note will come out,
tinkling.

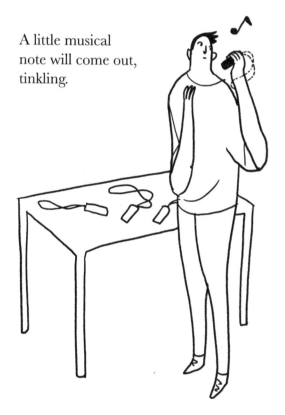

Hearing the note makes
you turn different colors.

Richard's artwork is paper-based.
It's flimsy and easily damaged.
It falls apart when it's touched.

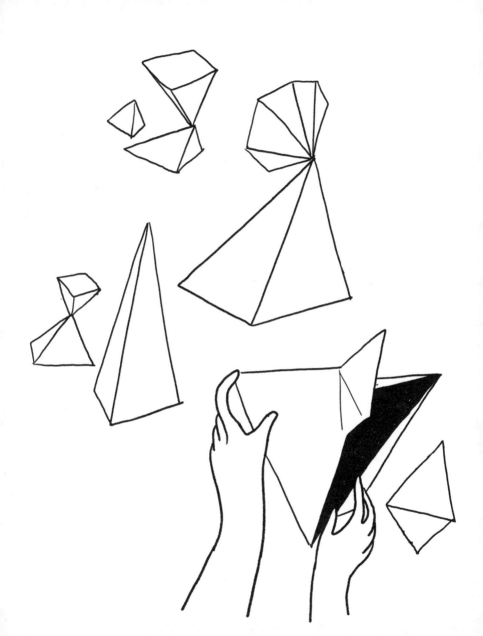

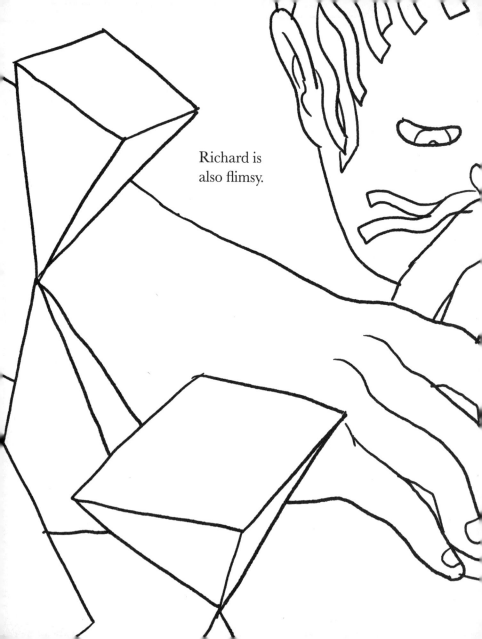

Richard is
also flimsy.

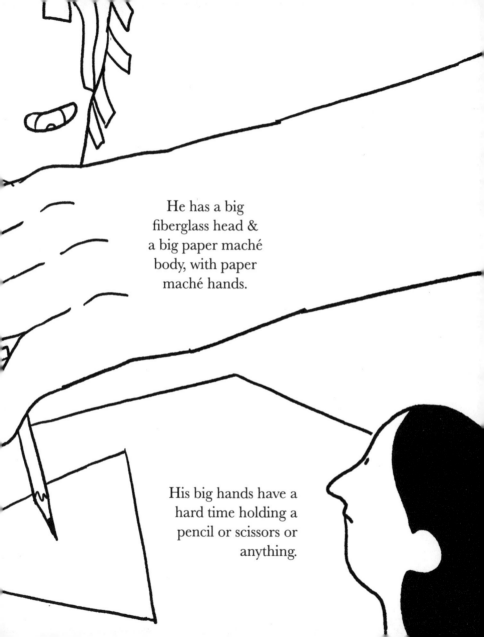

He has a big
fiberglass head &
a big paper maché
body, with paper
maché hands.

His big hands have a
hard time holding a
pencil or scissors or
anything.

Dolores ' work is performative, and she incorporates her audience into the artwork itself.

The performance is Dolores saying, *"I love you."* She says it to everyone, individually. Her artistry is that she makes us all really believe it.

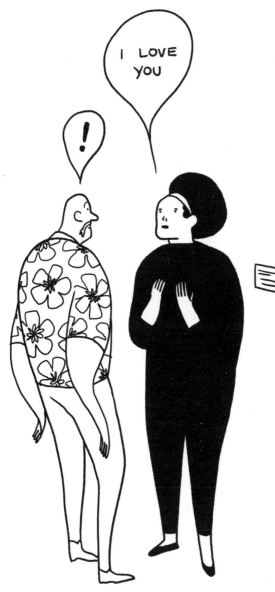

If she were a bad artist her art
would be a lie and people would
hate it. Instead, somehow she has
made the statement into her truth.

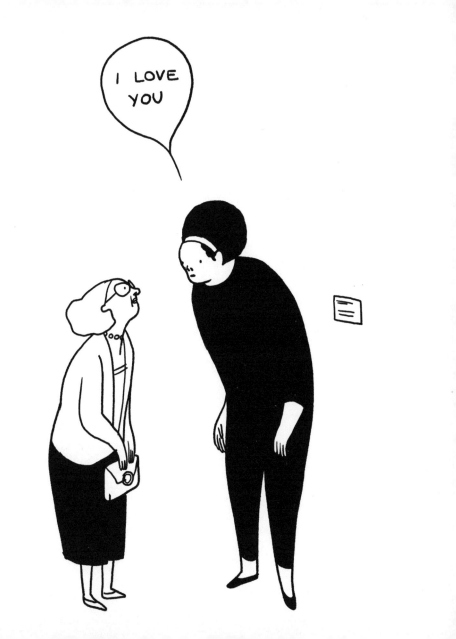

People often react
strongly to her work.

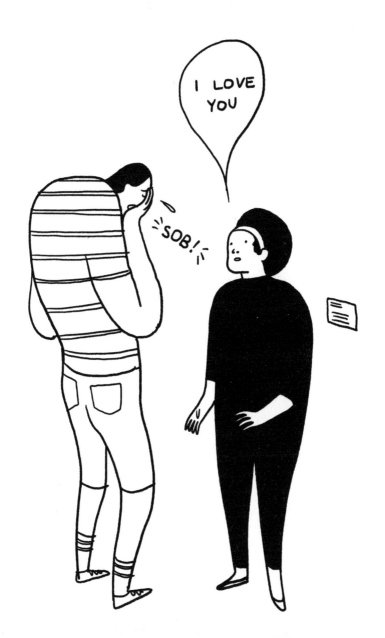

Some responses get
very intense.

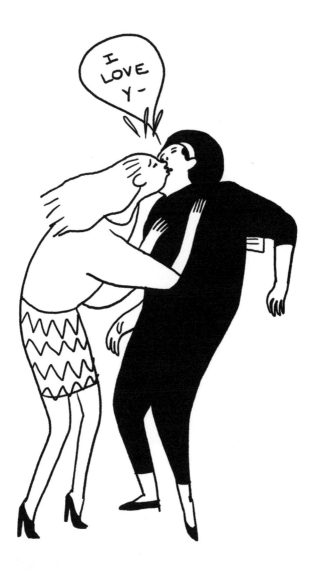

Dolores gets a lot of marriage proposals. Her suiters follow her around, to the grocery store, and back to her house.

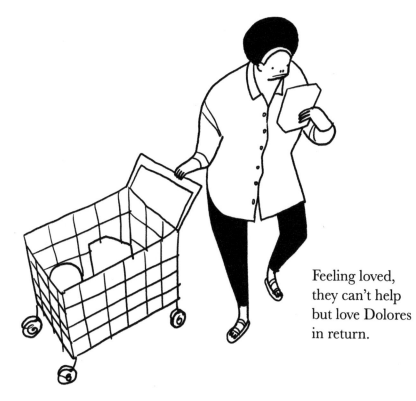

Feeling loved, they can't help but love Dolores in return.

Without further reciprocation they resort to stealing her stuff, her potted plants and lawn chairs. Dolores sometimes has to call the cops.

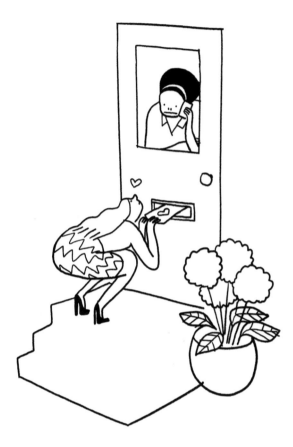

Under this kind of strain, the truth of Dolores' artwork becomes tenuous.

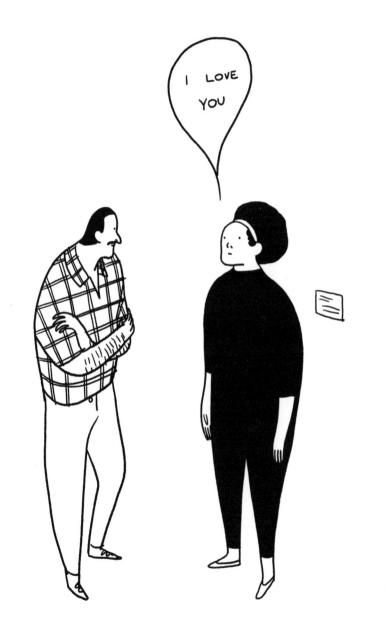

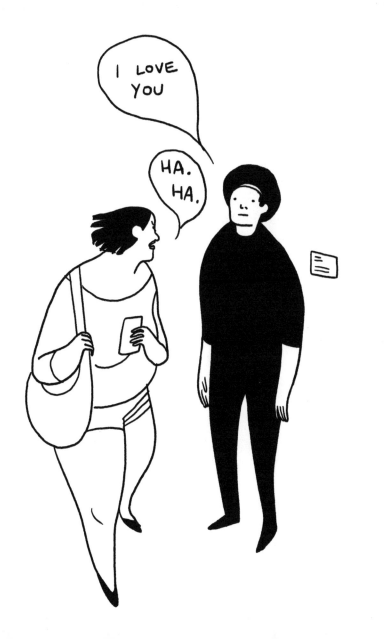

Dolores realizes the artwork has become bad now that it's no longer true. She goes away to work on another artwork. She travels for ten years.

In her travels she's attacked by a shark, who eats her arm. She has to relearn how to do everything with her left hand, including tie her shoes and play the guitar. She reads all the great works of literature. She pulls a river out of its course and then puts it back again.

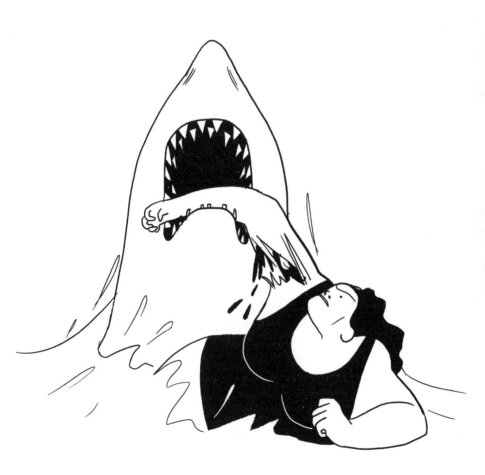

She finally tracks down the shark who ate her arm, and **she** eats **it**. She grows a new arm, and shark teeth. She takes a printmaking class. She has a baby, and then another baby, and she carries them in great holes in her back like a frog. And she makes another artwork.

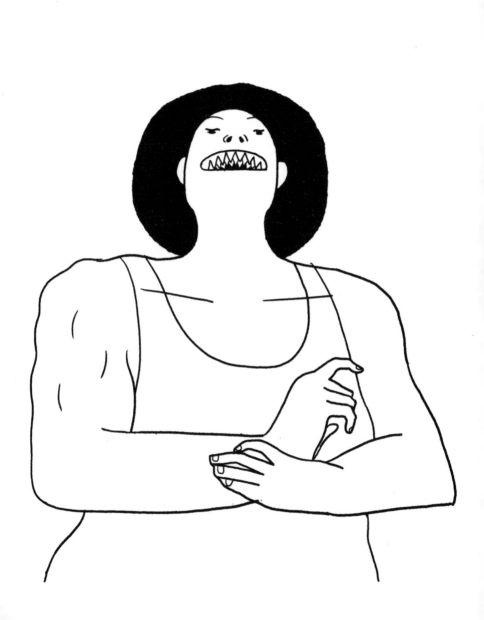

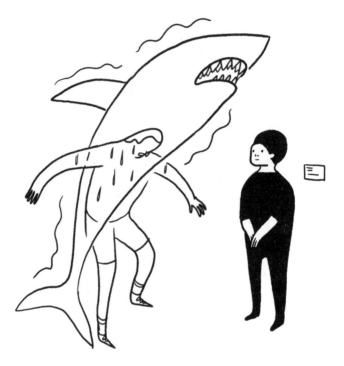

In the new artwork you are
attacked by a shark, and grow
shark teeth, etc, too.

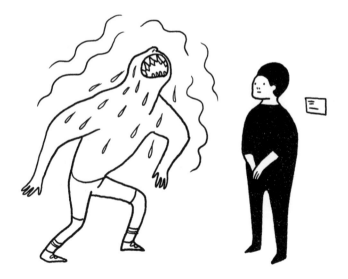

Audiences respond strongly to this new artwork.

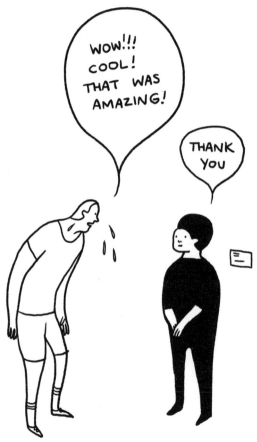

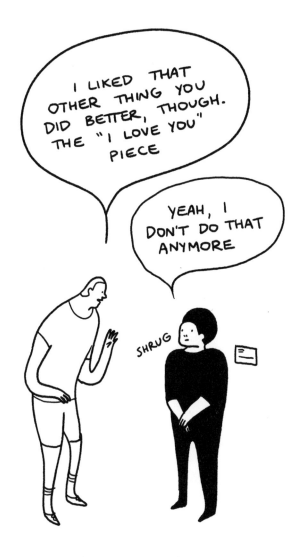

Now that **Dolores** has returned, she and **Richard** and **Ju-Long** and **Mike** and **Sophia** and **Makayla** and **Jennifer** and **TwiceTwo** and **José** are all getting together for another show.

They are each presenting their newest works. They've been exploring multiple modalities of communication, including time and soundscape. They're pushing boundaries and breaking barriers — psychological, physical, metaphysical, and temporal.

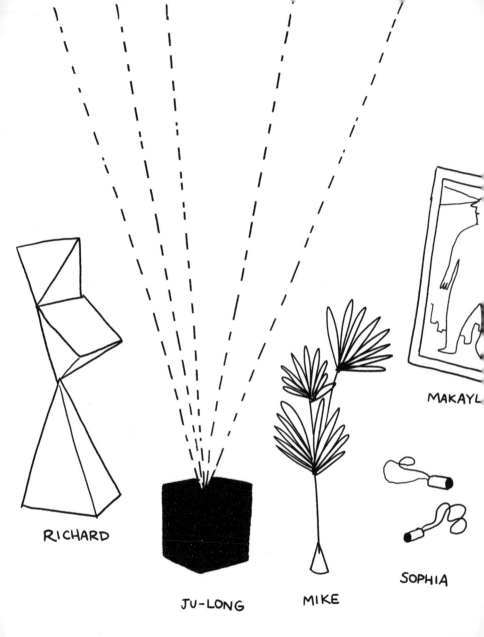

RICHARD

JU-LONG

MIKE

SOPHIA

MAKAYL

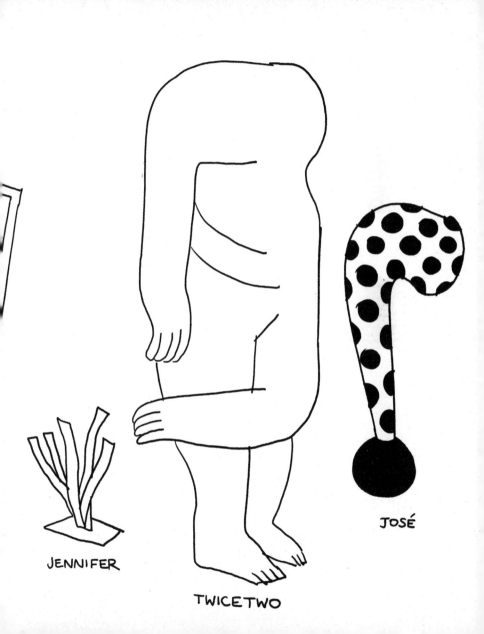

JENNIFER

TWICETWO

JOSÉ

But there's a storm
raging outside.

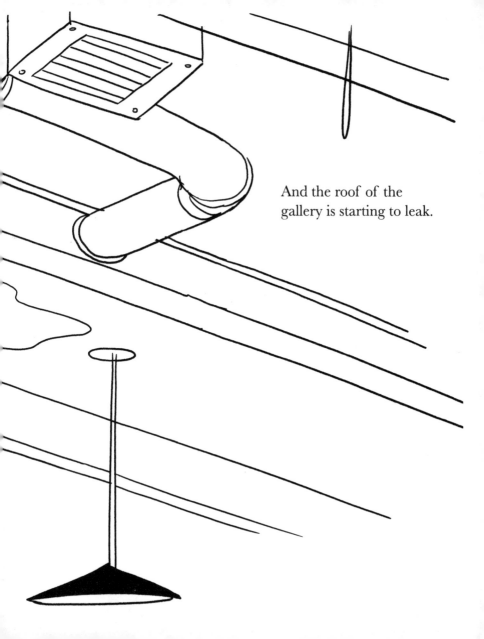

And the roof of the gallery is starting to leak.

Some of the water leaks on Richard's big paper maché hands and he starts coming apart.

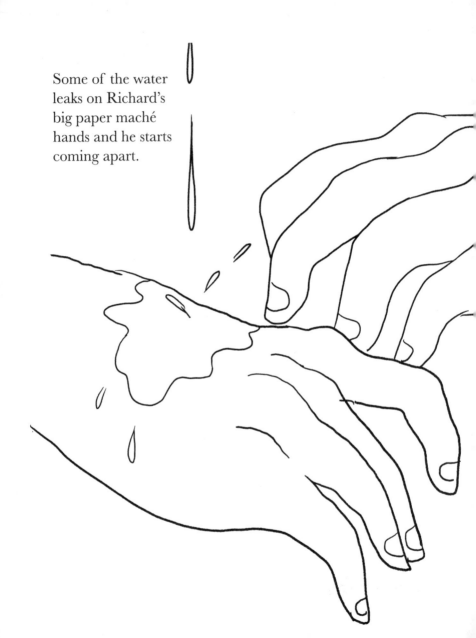

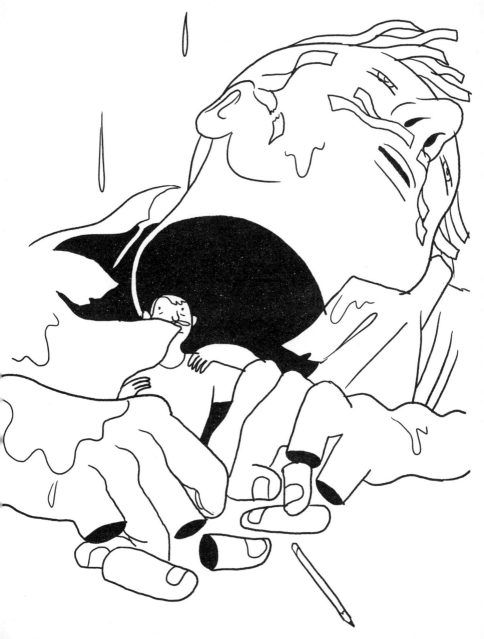

It turns out there is a smaller human Richard inside the fiberglass & paper-maché Richard. The smaller Richard can hold a pencil much more easily.

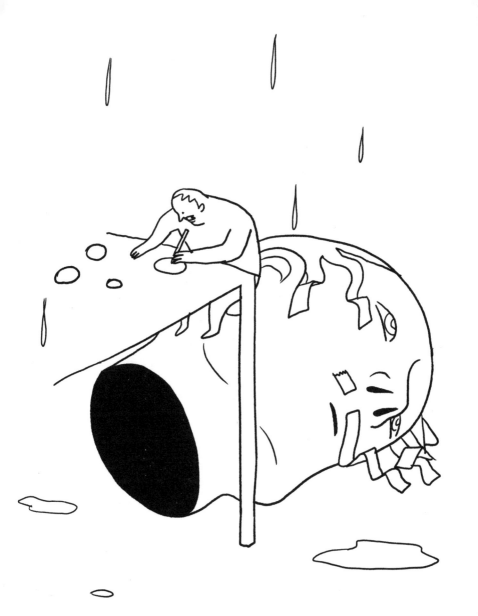

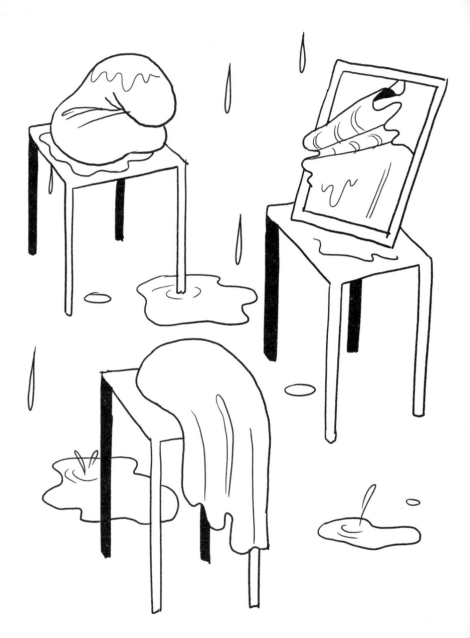

The leaks are getting worse. Some key pieces are damaged and the show hasn't even opened yet. And we're worried about attendance, because of the storm. We can hear the roar of the wind, and thunder. We hear shouting, explosions, rushing water, and the thrumming of a million insects.

Chunks of plaster start falling off the ceiling. Everyone is scrambling to protect their artworks. Little artworks are put into big artworks. Fragile artworks are put into sturdy hollow artworks. The air is filled with smoke.

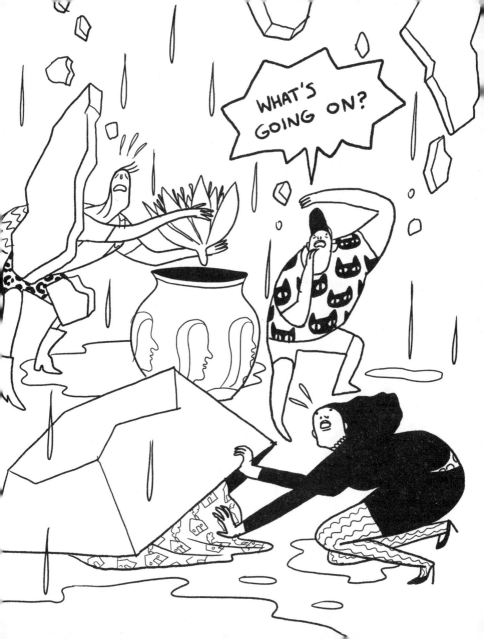

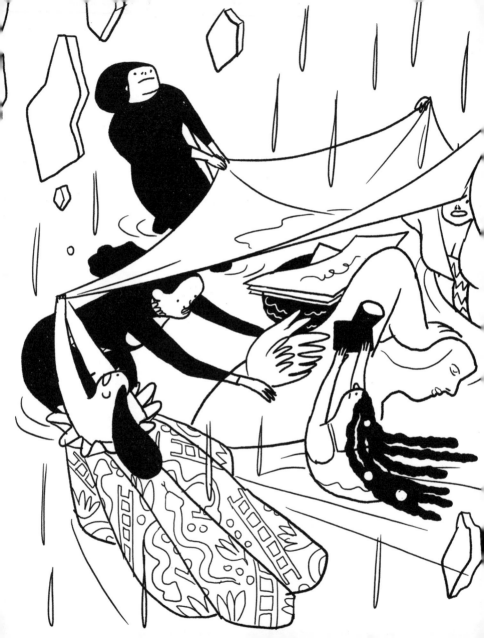

The roar of the wind is deafening. The puddles on the floor join together and get deeper. We try to pile the stuff that shouldn't get wet — the silk things & paper things — on top of the stuff that can, like the things made out of marble or old tires.

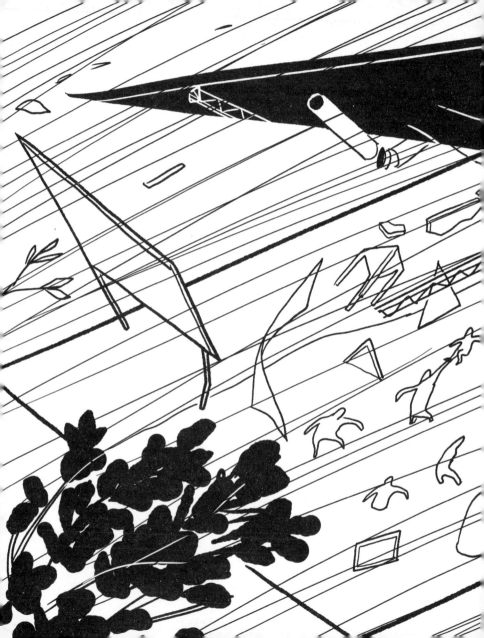

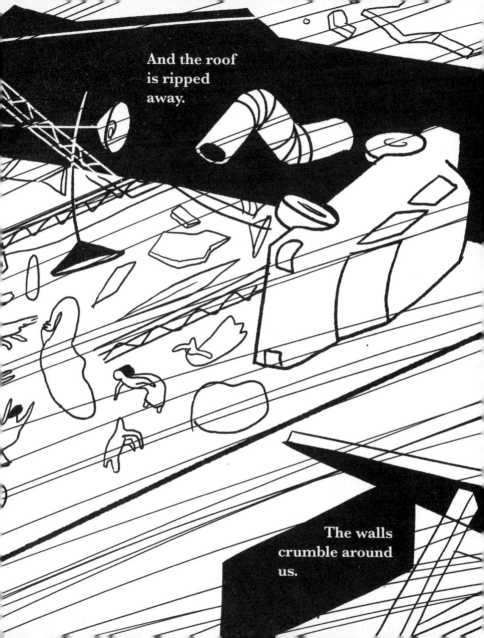

And we look up. The wind is deafening. Everyone's clothes are plastered to their bodies from the rain. Everyone is waist deep in water.

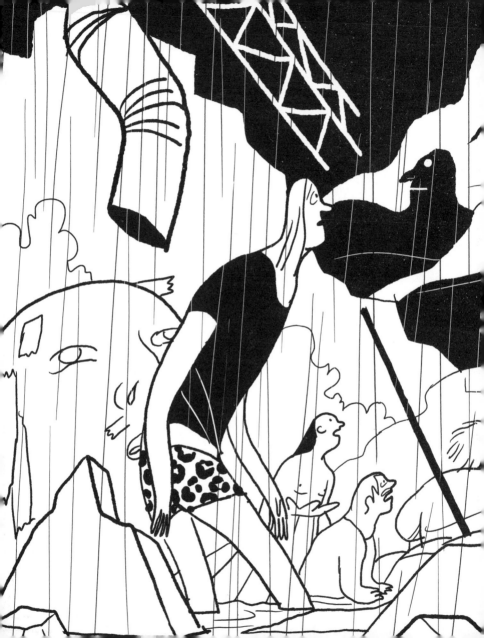

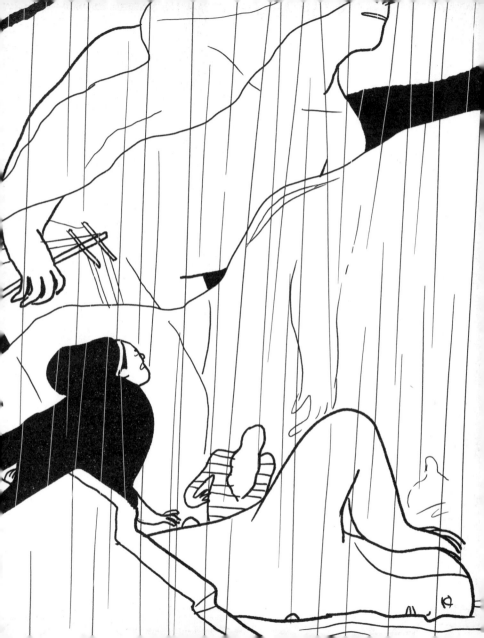

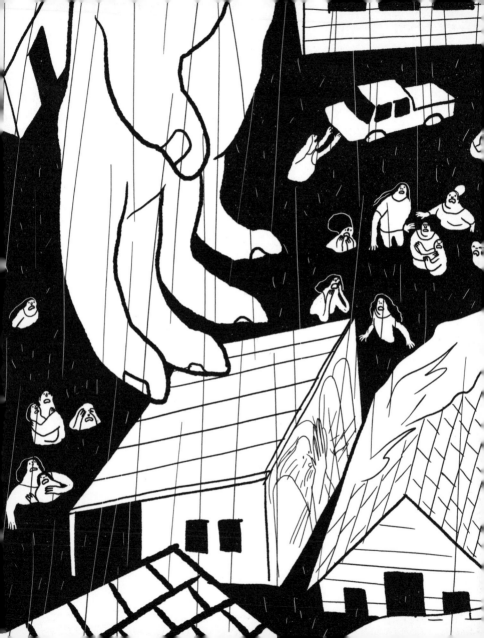

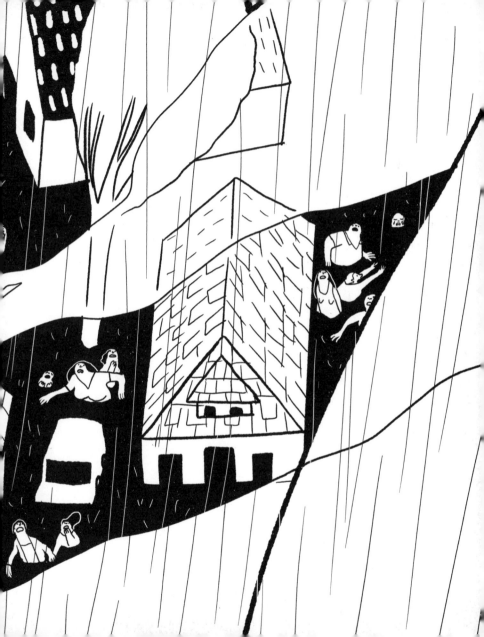

The streets are filled with people. Some of the people are trying to run or hide; some of them are standing still. Mothers and fathers are yelling for their children and gripping them to their chests, or shielding them behind their backs. Old and weak people, who have a hard time standing, are being held up by people who are strong. Our faces are lit up from the fires burning all around.

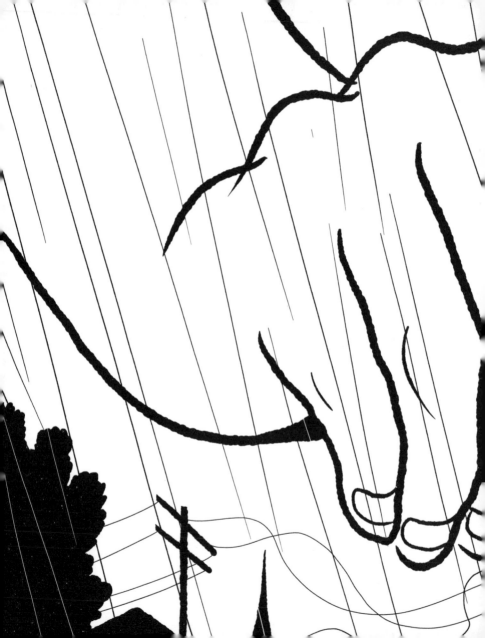

A hand reaches down and picks up a little house. It rolls the house between its fingers.

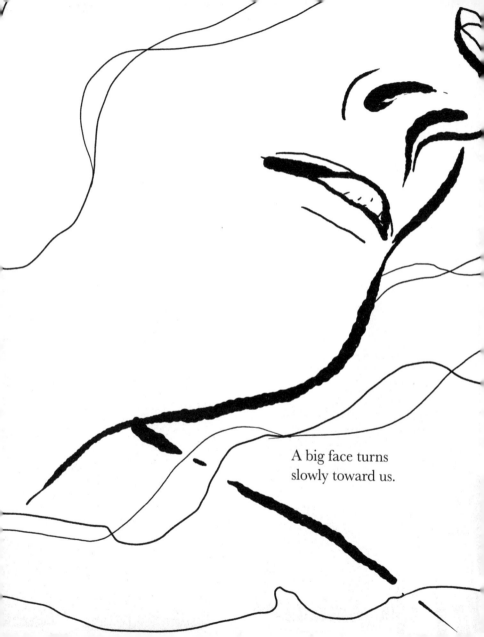

A big face turns
slowly toward us.

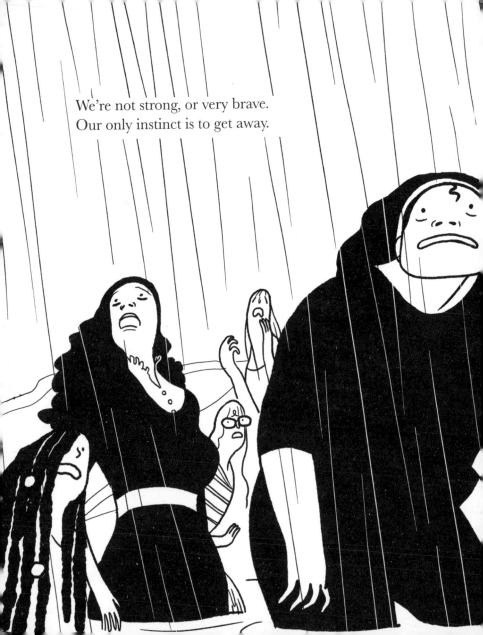

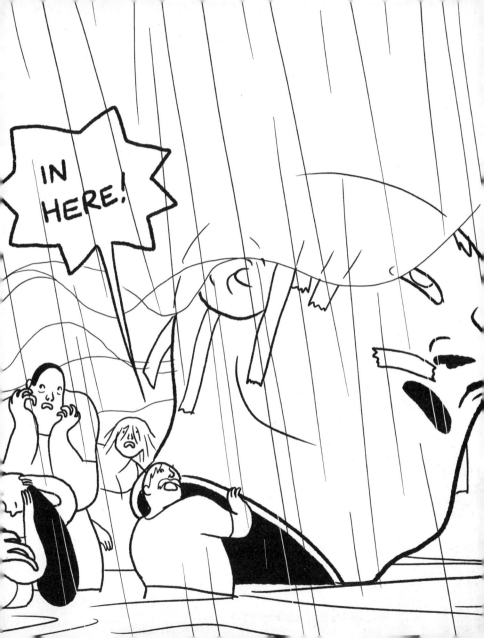

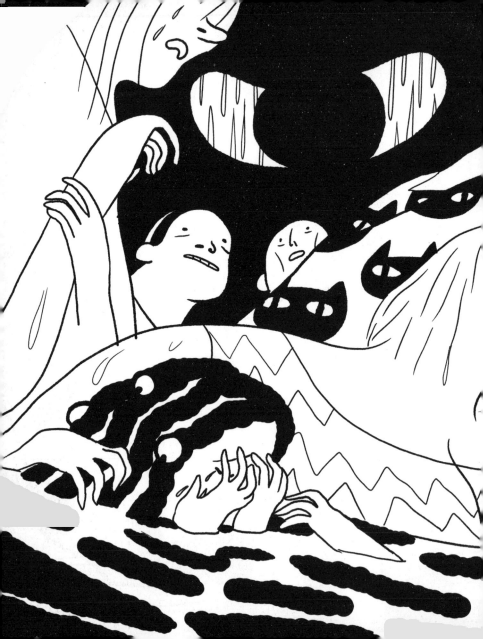

We can see the flicker of flames projected on the inside of Richard's fiberglass head.

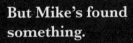

But Mike's found
something.

It's a very small **Shadowbox** artwork, very tiny. The inside is bright with jewel-like colors: green grass, and flowers in full bloom.

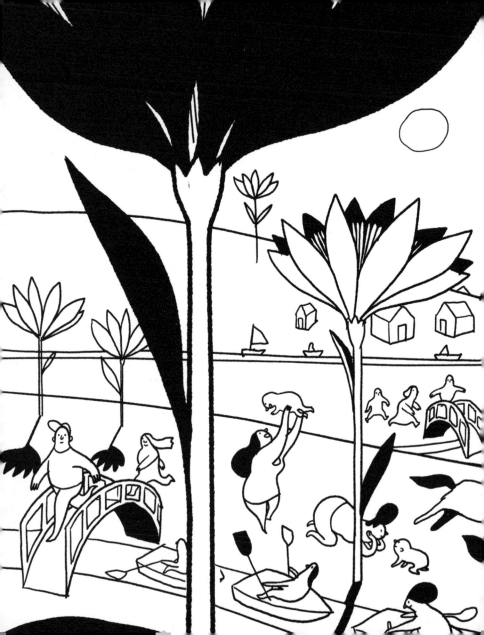

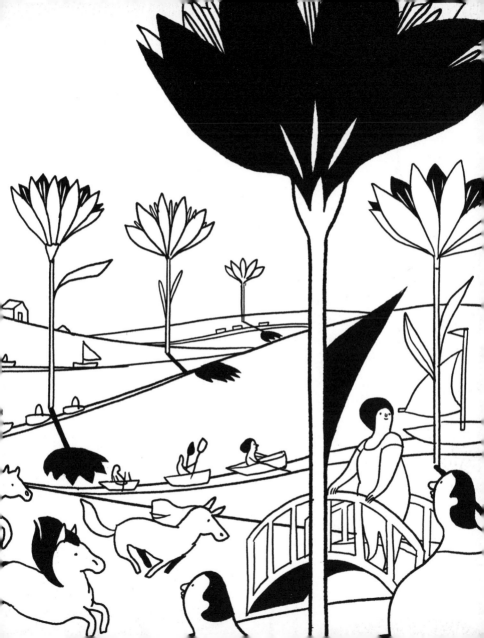

The flowers are big and deep red, with velvety, thick petals, and stamens covered in golden pollen. Their stems are green, and strong, and straight. The clear sky is deep blue above, and a gentle sea-green along the horizon. The sun is lemon yellow, shining down.

And everywhere there are people and horses and rivers running: bridges cross back and forth over the rivers and many people are crossing back and forth over the bridges, while other people in rowboats cross back and forth under the bridges, traveling up the rivers and back down again.

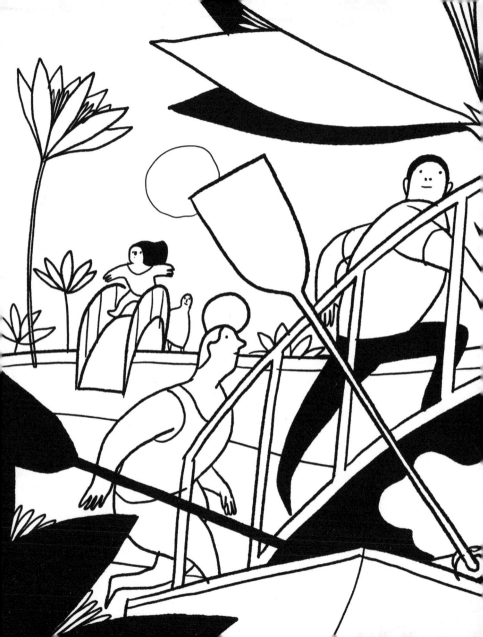

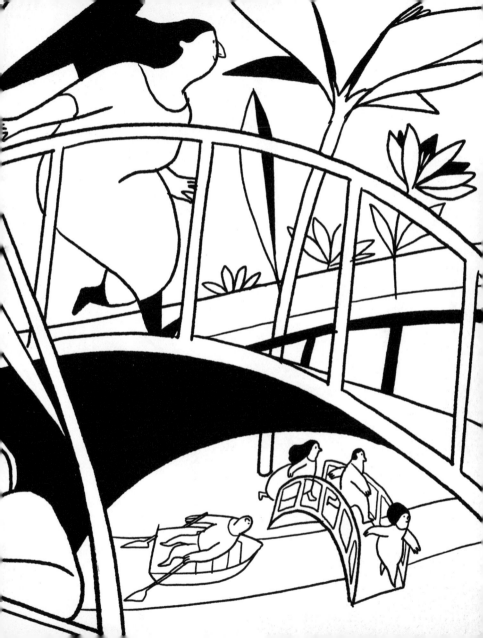

The people reach their hands out to us and pull us up out of the water.

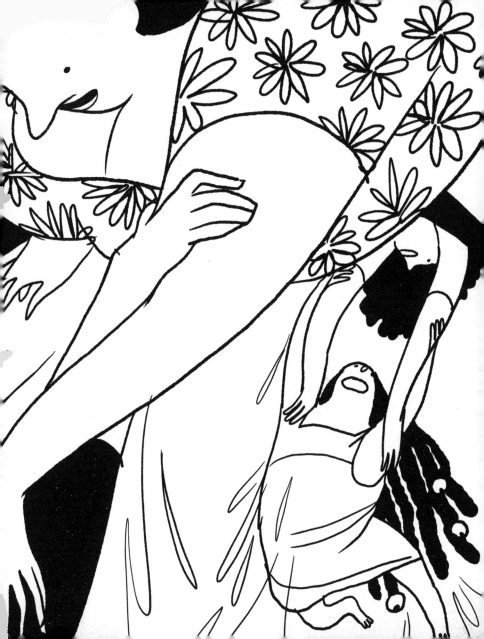

They wrap us in towels, and give us hot drinks, and we lay in the grass to dry off.

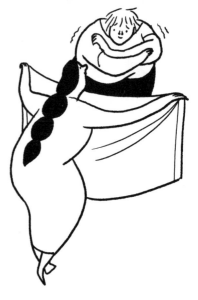

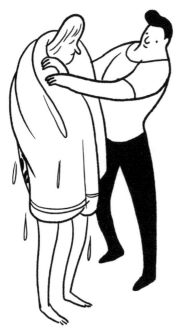

Makayla has rescued some of Jose's edible artworks, and we eat them.

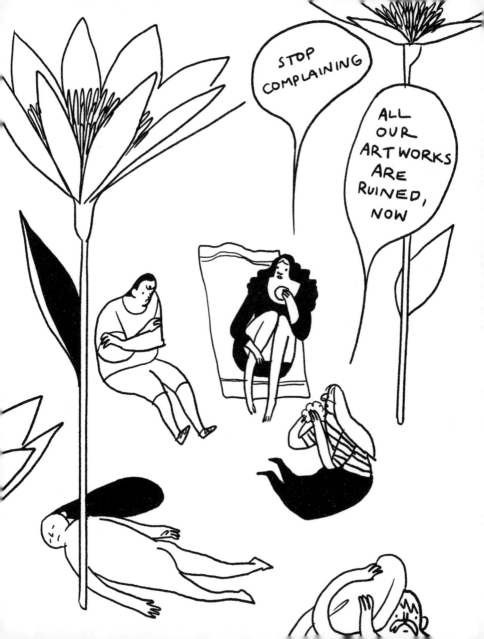

We look around. The people here are happy and beautiful; they're kissing, and cooking food, and singing soft songs. They reach out to one another and look at each other with clear, honest eyes, smiling wide, easy smiles.

Babies are being born, and washed and swaddled and lifted up into the air, until they swell into kids who are too big to be lifted into the air, so they're spun around in circles until they swell into strong, healthy adults who are too big to be swung around in circles, and now it's their turn to lift babies into the air; and now it's their turn to spin children around.

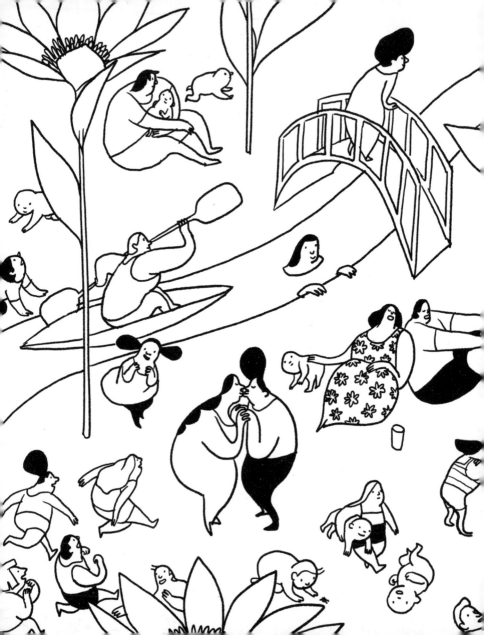

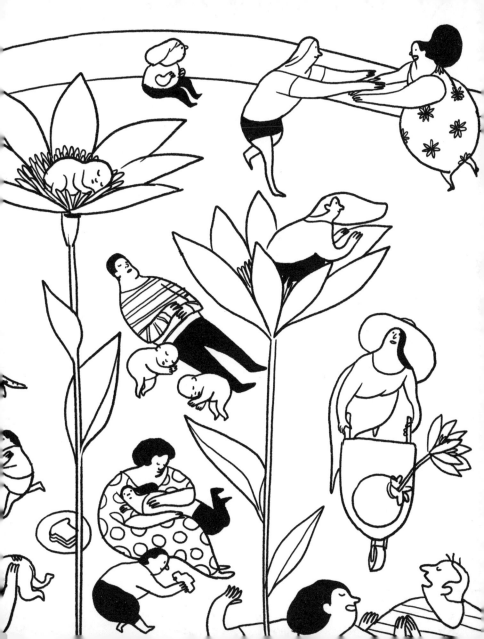

We're laying under the giant flowers with the thick green stems and huge red petals, and there are birds flying everywhere, building their nests in the leaves and in holes in the stems. We can still hear the soft sounds of far away destruction. We can still smell the smoke.

We watch the birds building their nests out of beautiful pieces of gold thread and smooth colored glass.

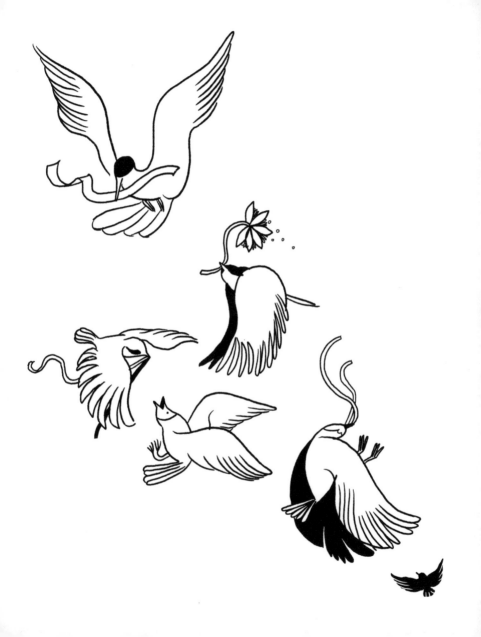

And Dolores starts
doing something.

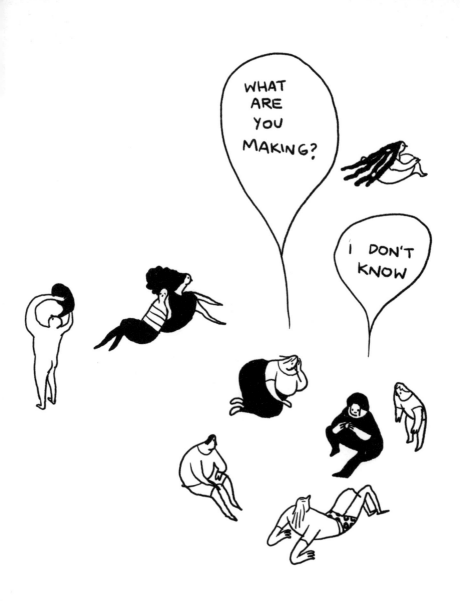

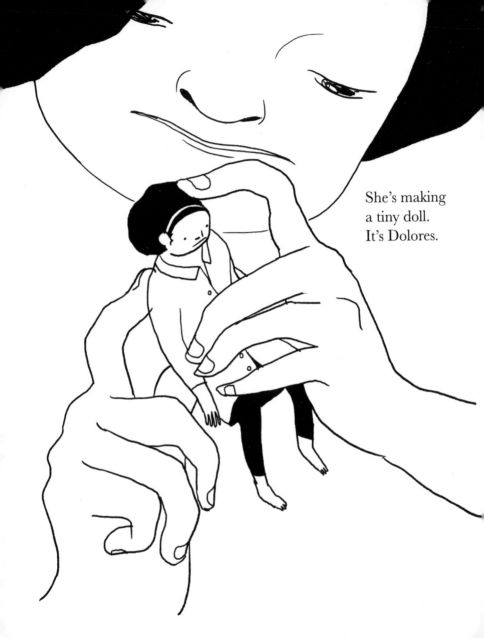

She's making
a tiny doll.
It's Dolores.

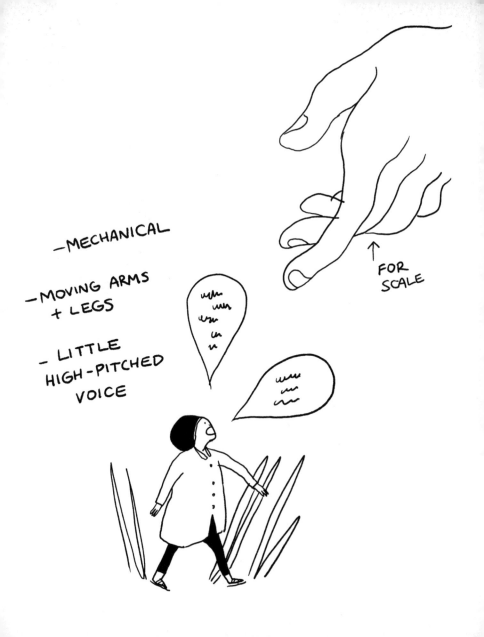

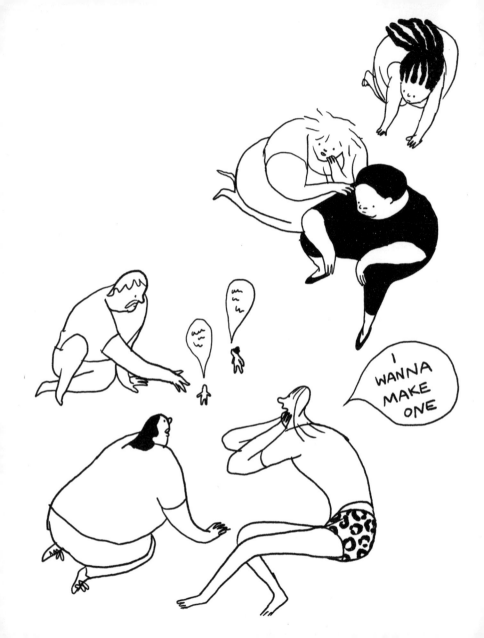

Richard makes one too, a tiny
Richard. It looks so fun. We
all get into it, until there are
nine smaller versions of us,
getting to know each other.

Then we make the gallery we had
been in, out of pieces of paper, and
grass, and string, and the remains of
our old wrecked-up artworks.
We make the tables, and bathrooms,
and cheese plates, and plinths,
and folding chairs, and everything
else. We put ourselves in it and let
ourselves walk around.

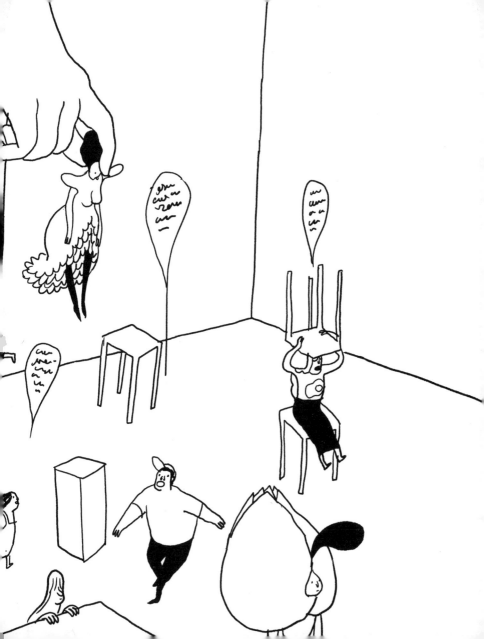

Our unruined lives.

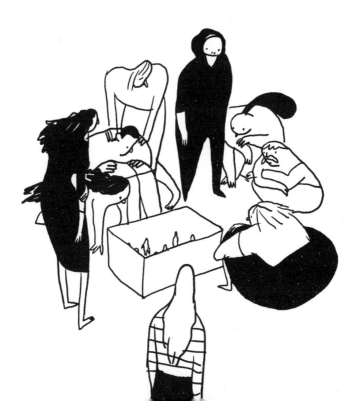

The little versions of
us do their own thing.

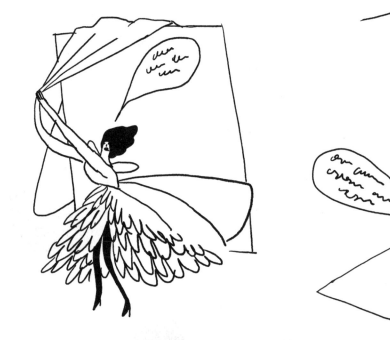

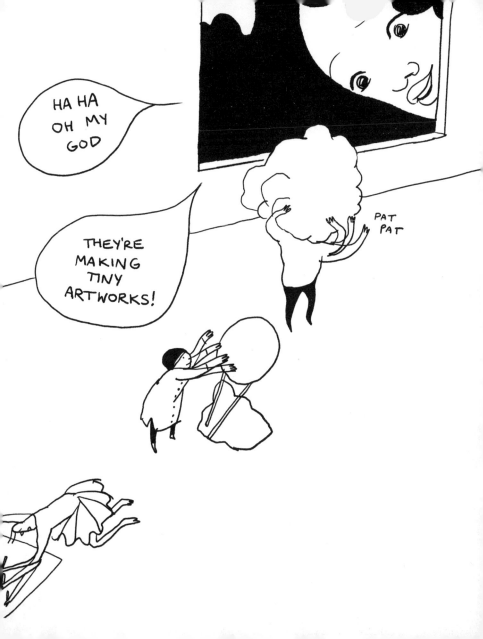

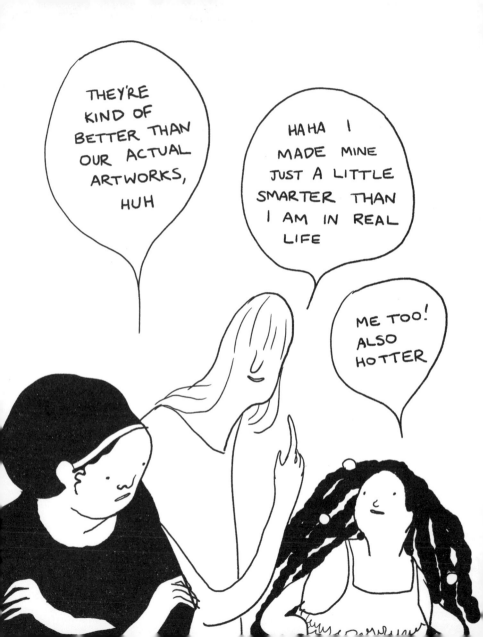

Because we built these tiny versions ourselves, we made them a little closer to how we'd like to actually be.

We watch our small selves for a long time. We worry that they will get hungry, and there won't be enough cheese plates, or that they'll get bored; so we start building the other things. We build the people outside the gallery, the cars and houses, fast food restaurants and tanning salons and parks and check-cashing places.

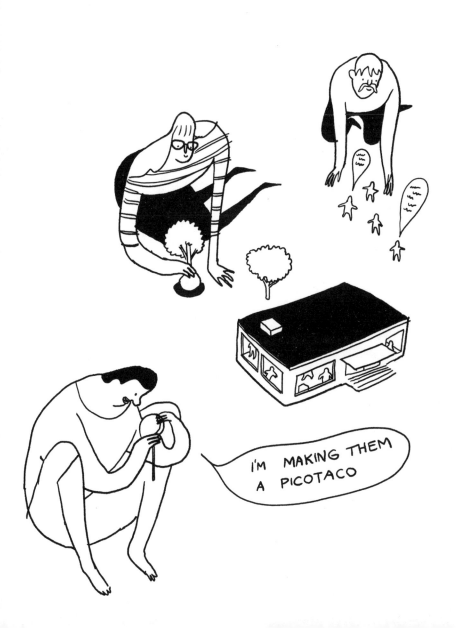

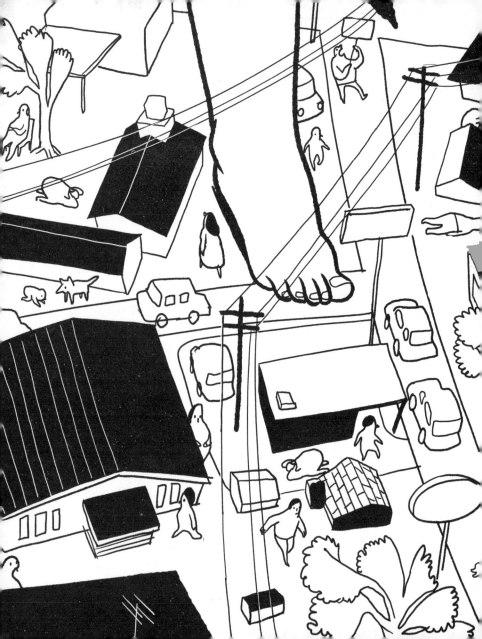

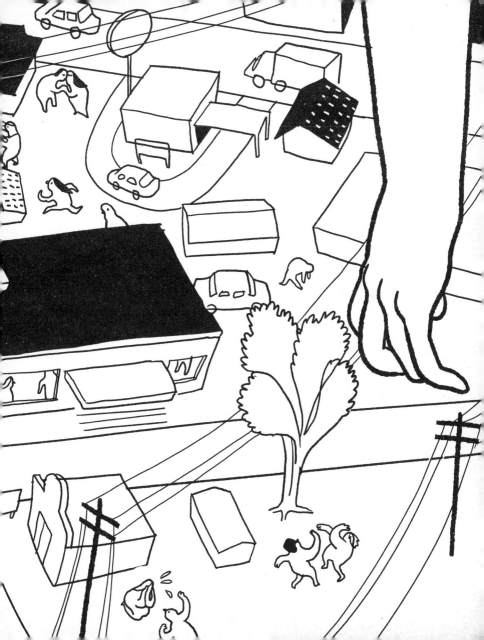

We build everyone we know. When we've built everyone we know we build everyone *they* know, and then everyone *those* people know and everyone *they* know. We rebuild our entire world. We move carefully through it, on tiptoe, so nothing gets hurt or broken.

But then, Dolores —

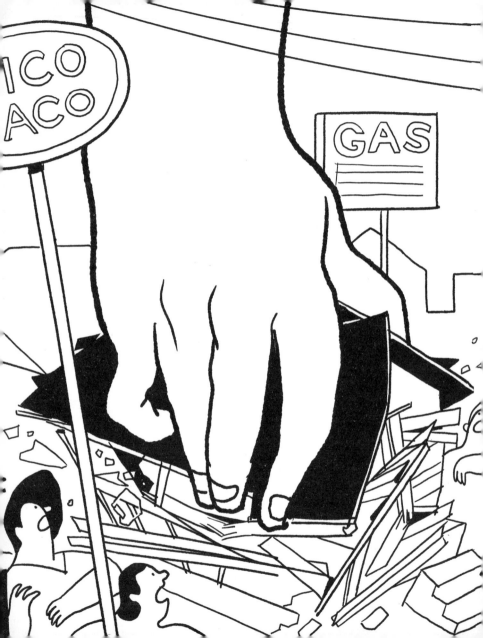

Dolores reaches down and picks up a little house. She rolls the house between her fingers.

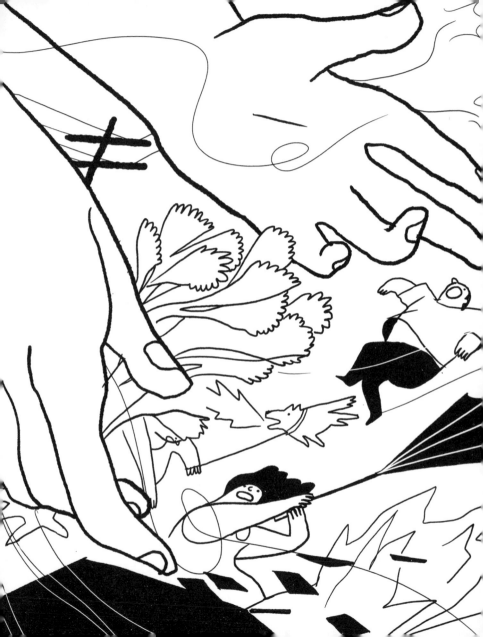

She stirs up strong winds with her huge hands. The smashed buildings catch on fire and fill the air with smoke.

We're shouting and trying to stop her, but we accidentally knock over powerlines and kick over cars and the destruction gets worse. Rain starts to fall.

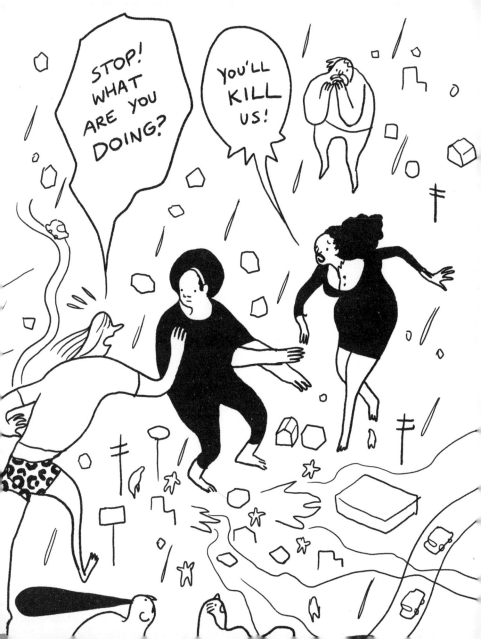

The people who we know and the people who we don't know fill the streets, looking up at us, their faces in their hands, standing still or trying to run, yelling for their children, holding up their parents, pummeled by tremendous raindrops, pushing through the waist-deep water, clinging on to one another.

And Dolores says —

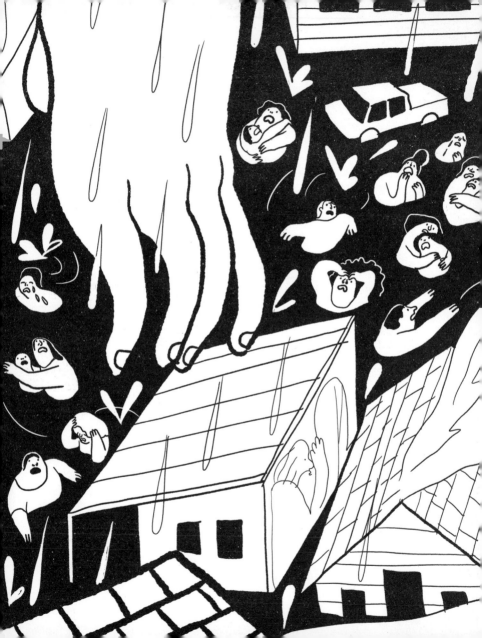

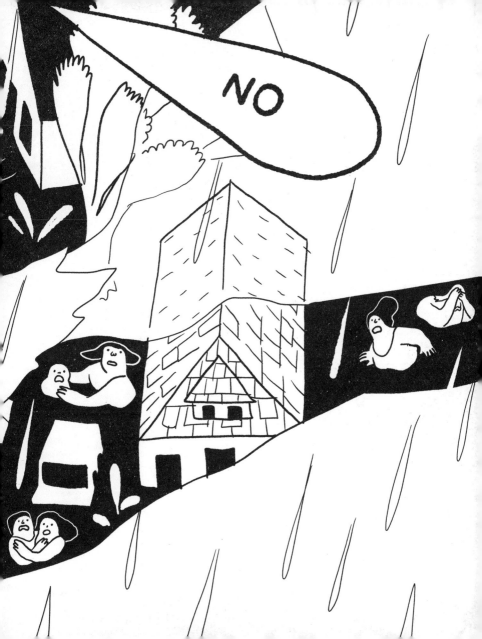

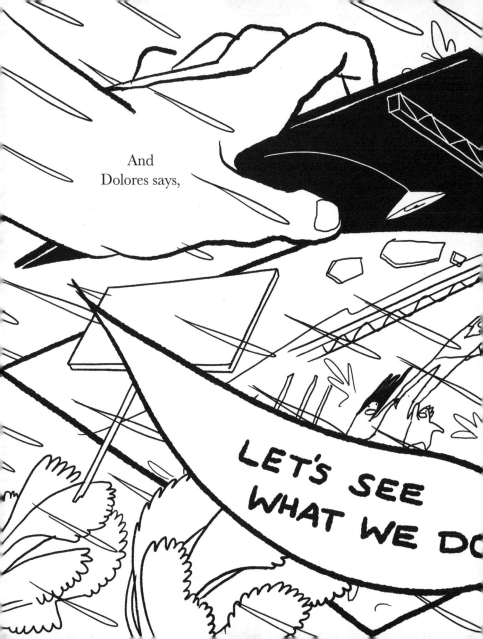

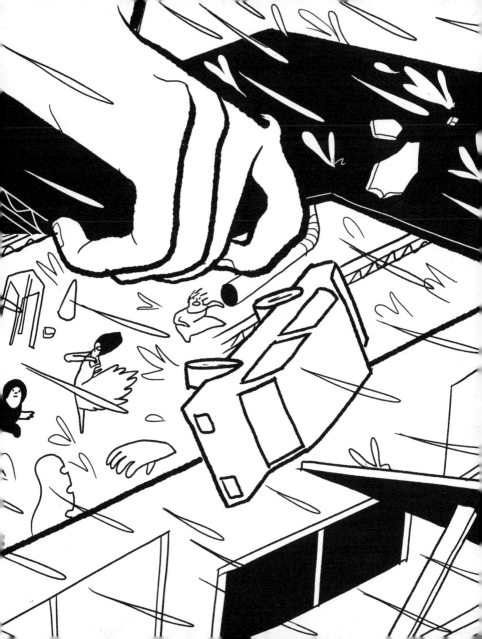

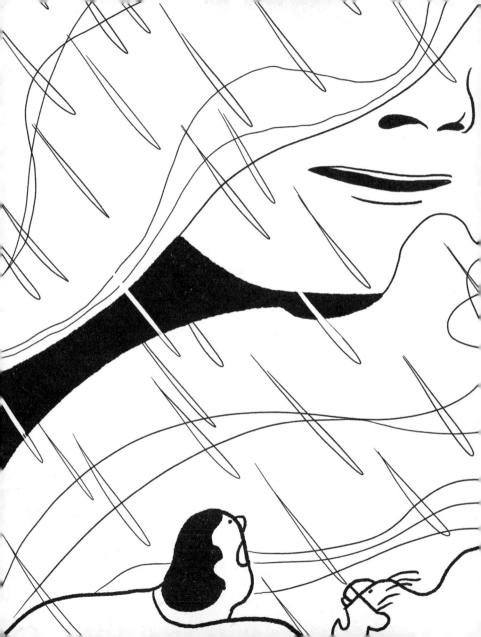

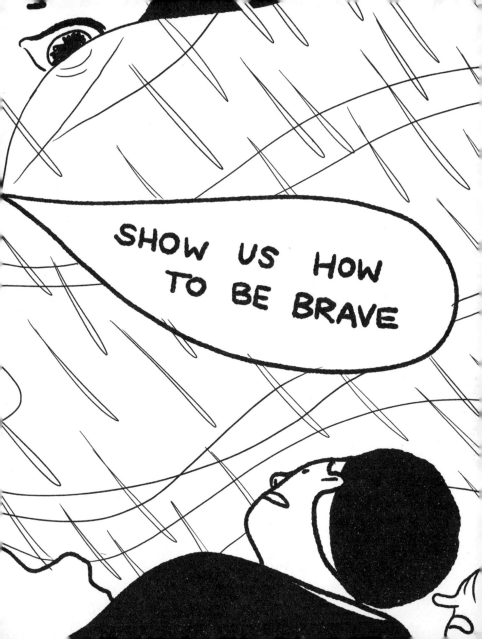

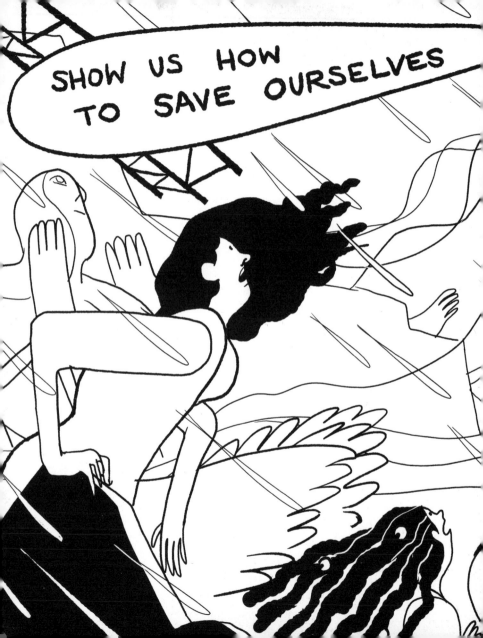

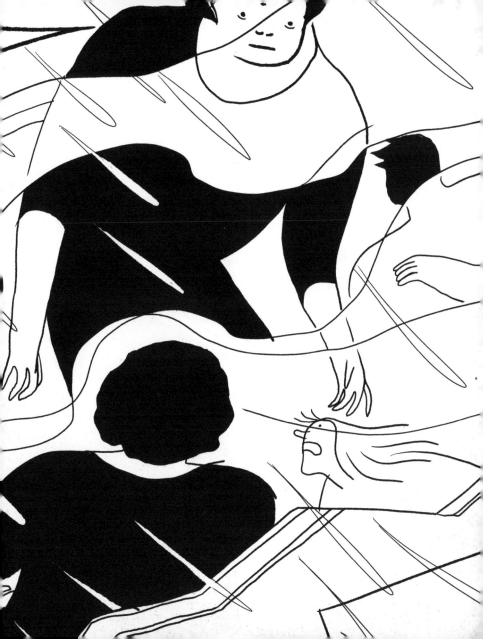

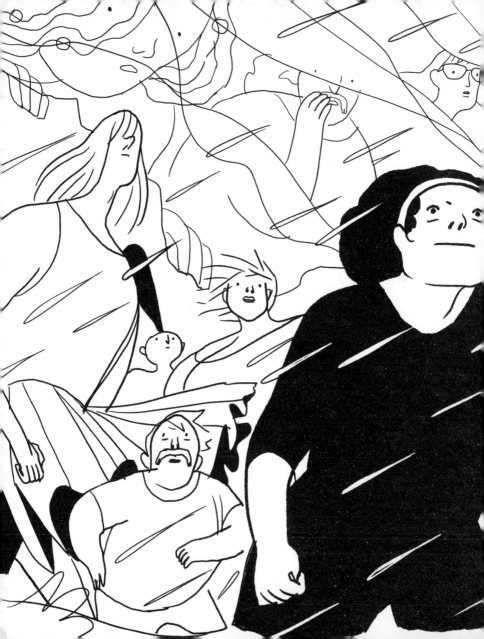

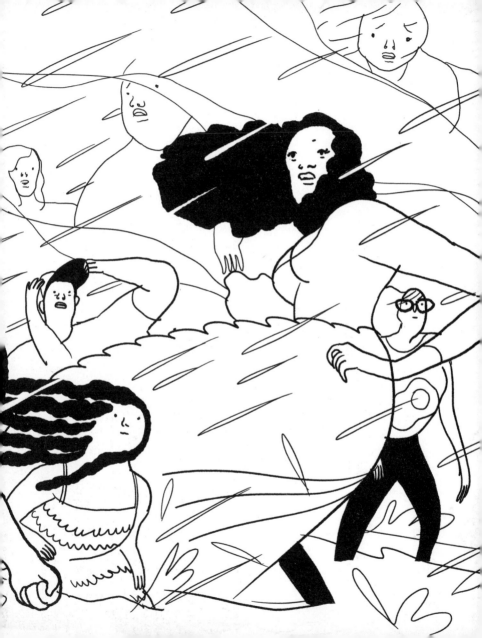